Contents

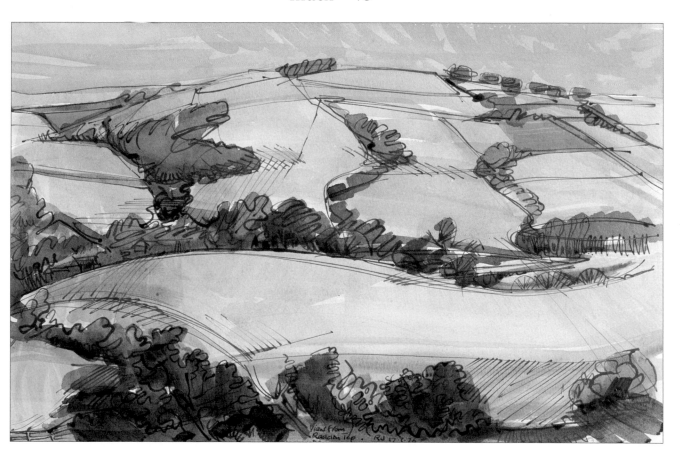

Introduction

Adding line work with a pen can change a watercolour painting beyond recognition. Much will depend on whether or not you are a purist. It would be almost criminal to apply outlines and tone effects to an exquisitely-executed watercolour; the medium of watercolour is complete in itself, with techniques to suit almost any requirement.

Pen and wash – or line added to any medium – can be a strengthening influence; a way to emphasise detail; a form of graphic lift. It is particularly suited to sketching because it offers fast, clear results; a rapid response when the weather is bad, for moving objects and rapidly-changing scenes. It is *drawing* rather than painting.

It is true to say that near-perfection can be achieved in any medium, but not for most of us! In my experience, a watercolour has a life of its own and I need all the help I can muster. With just a few deft strokes of a pen what was formerly a jumble becomes far more obvious. It is the drawing that appeals to me; even when using other mediums I tend to draw salient features not just for outlines but to give them body.

So, do you draw and colour within the outline, rather like a hand-tinted etching? Or do you first establish a colour image? This may well depend on the subject. A building or technical feature may require precision and definition, whereas a landscape may rely on bold colour washes, held together by a suggestion of form.

The level of your drawing or watercolour ability may also be a major factor. My instinct has always been to paint first and to draw afterwards, mainly because my watercolour skills lack the finesse to which we all aspire. I prefer to establish a colour 'feel' to the whole work, then build in the detail.

When painting indoors – and if you have room – try to have everything you need close at hand. I make sure there is a pot for clean water and another for washing brushes, plus a supply of paper towels or cloths. I have a normal level table as well as a standing desk: I do most of my painting standing up because I feel it allows me to be more relaxed when working, and I can also stand back and look at my work more easily. A high stool is useful when you are working on a meticulous and tiring project.

For working outside, there will be times when you will need to support your paper or pad at an angle to aid the flow of paint. I take an adjustable easel, but how much you take on a painting expedition will depend on several factors, including your age and the distance to be travelled. As a general rule, do not take too much but make sure you have what you need to be comfortable.

Pen lines can be added to a composition at almost any time, and may enable you to paint on a boat, in a cramped car or in a howling gale. In fact, you may find that pen and wash is the gateway to freedom.

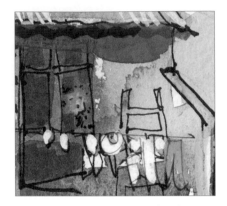

A detail of the picture, right, has been enlarged to show the line work.

Barcelona Life
This glimpse of city bustle was seen from a window overlooking the rear of a block of flats. The scene teems with action, which had to be captured instantaneously. The aerials on the roof and the washing strung from the lines help to make it an ideal subject for pen drawing with added colour – and you can almost hear the clicks of the mah-jongg counters in the basement.

size: 250 x 290mm
(9¾ x 11½ in)

Pen & Wash

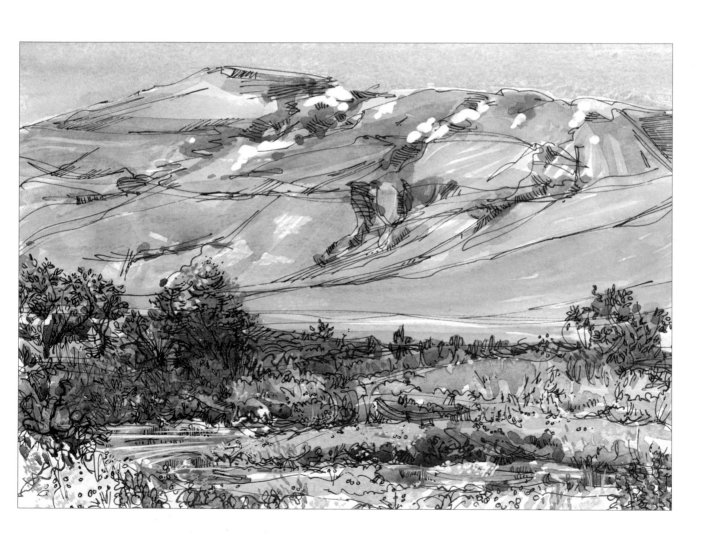

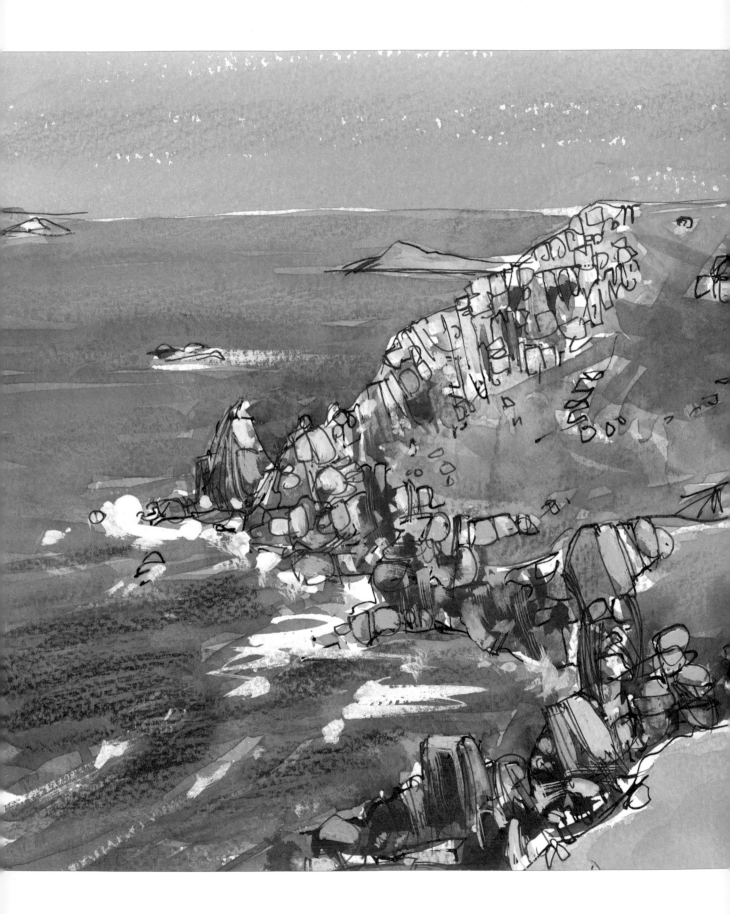

Pen &
Wash

ROBERT JENNINGS

SEARCH PRESS

First published in Great Britain 2002

Search Press Limited
Wellwood, North Farm Road, Tunbridge Wells, Kent TN2 3DR

Reprinted 2004

Text copyright © Search Press Ltd. 2002

Photographs by Lotti de la Bédoyère, Search Press Studios
Photographs and design copyright © Search Press Ltd. 2002

ISBN: 0 85532 966 1

The publishers and author can accept no responsibility for any consequences arising from the information, advice or instructions given in this publication.

The publishers would like to thank Winsor & Newton for supplying many of the materials used in this book.

Suppliers
If you have difficulty in obtaining any of the materials and equipment mentioned in this book, please visit the Search Press website for details of suppliers: **www.searchpress.com**. Alternatively, you can write to the Publishers at the address above, for a current list of stockists, including firms who operate a mail-order service, or write to Winsor & Newton requesting a list of distributors.

Winsor & Newton, UK Marketing
Whitefriars Avenue, Harrow, Middlesex HA3 5RH

Publisher's note

All the step-by-step photographs in this book feature the author, Robert Jennings, demonstrating how to draw and paint with pen and wash. No models have been used.

There is a reference to sable hair brushes in this book. It is the publisher's custom to recommend synthetic materials as substitutes for animal products wherever possible. There is a large number of artificial fibre brushes available and these are satisfactory substitutes for those made from natural fibres.

Printed in Spain by A. G. Elkar S. Coop. 48180 Loiu (Bizkaia)

I would like to thank the very helpful staff at Search Press for their patience and assistance, particularly Alison, Roz, Lotti and Juan. Thanks also to Phil Mingo for the photographs on page 11.

I hope this book will encourage artists of all ages and levels of skill to go out there and paint with conviction. I believe that it is all about attitude, and that the skills will come if one feels strongly enough to try anything.

*cover: **the Winter Palace, Luxor***
size: 245 x 175mm (9¾ x 7in)

*page 1: **Hamkadalur, Iceland***
size: 245 x 175mm (9¾ x 7in)

Page 2/3: Mayon Cliff, Land's End, Cornwall
actual size

*opposite: **Hot Summer, Devon***
size: 380 x 250mm (15 x 9¾ in)

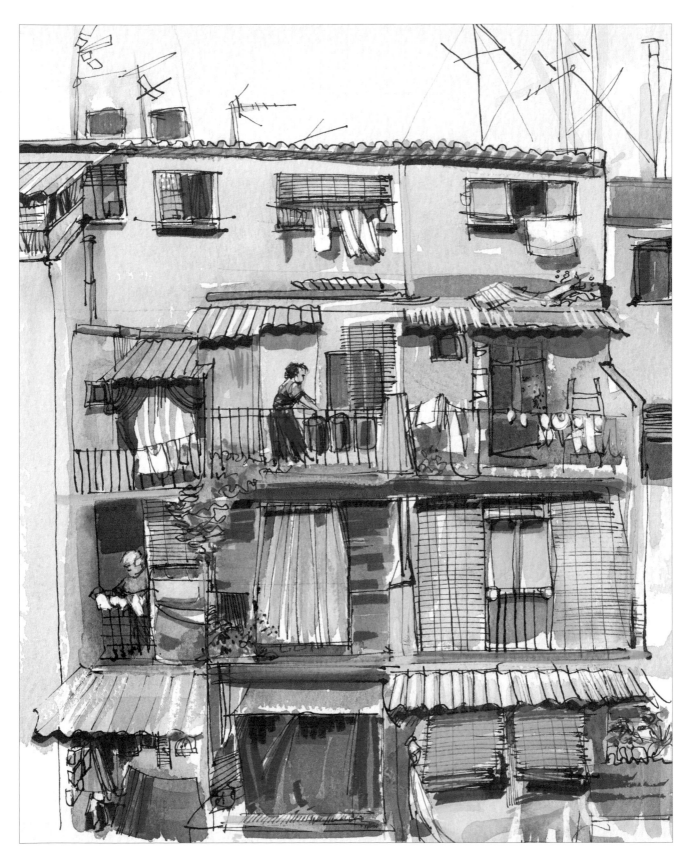

Materials

My colours

The three primary colours are reputed to provide all the shades you will ever want. Do not believe a word of it. A paintbox could set you off on the wrong course too: far better to be advised by someone whose work you admire.

The selection of colours I use was shown to me by an art society demonstrator many years ago and, with occasional changes for special effects, I have followed it ever since. His range was simple:

New gamboge is a rich, powerful bright yellow which gives a range of greens, and tones in well with siennas and umbers.

Raw sienna is useful for grasses and neutral backgrounds, and another mixer for greens.

Light red combines with yellow to provide all the reds you will need, and with blue and sienna for a full range of greys.

Winsor blue is strong, deep and cold, and comes in two variations: green shade and red shade. I use the green shade.

Extra colours, when I feel the picture will benefit, are **lemon yellow, burnt sienna, alizarin crimson** – and I also admit to a tube of **permanent sap green**!

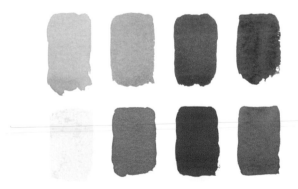

Top row, left to right: new gamboge; raw sienna; light red; Winsor blue.

Bottom row, left to right: lemon yellow; burnt sienna; alizarin crimson; permanent sap green.

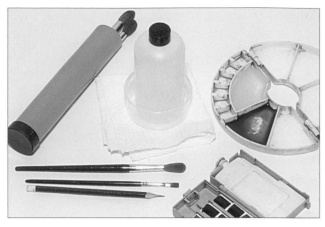

My outdoor painting kit

Paints

I find pans of colour convenient when I am working outside and for quick sketches, but it can be difficult to gather enough colour for a fair-sized wash. I also use tubes, especially when working indoors. When pans are empty, you can refill them from a tube, but remember the paint will have a different consistency.

Brushes

To make the most of your skills, good brushes are essential. Buy the best you can afford: they generally retain their shape better and last longer. I use round sable brushes in Nos. 1, 4, 6, 8, 12 and 14, plus two sable flat brushes. I also have many old-faithful brushes. Watercolourists are forever inventing new shapes and styles to achieve all manner of effects. Outdoor painters can buy specially-shortened brushes to fit more easily into their travelling sets. Wash brushes thoroughly after use, occasionally with soap and water to remove ingrained pigment.

Palette

This should be large enough to hold enough colour for a good area of wash. For studio work, I use an old palette with slots at the top for individual pigments and plenty of space to mix colours. My outdoor palette has a lid which can be closed with the paint inside for a fast departure if necessary!

Drawing boards

I have a drawing board, but a rigid piece of board or plywood may be adequate. Most watercolours can be done on a table, using a board at a slight angle.

Paper

Paper is available in sheets and pads, in finishes from Rough, through Not (cold-pressed) to the smoother HP (hot-pressed). All can be used for pen work, though Rough is the most damaging to nibs and care must be taken. If you want to draw carefully with fine nibs, use smooth paper or even thin card.

I mainly use a heavier weight 140lb (300gsm) paper, and seldom stretch it. I also paint on traditional hand-made tinted paper which comes in 200lb (410gsm) and 300lb (630gsm) weights. For sketching, I make my own spiral-bound pads from favourite papers, usually Rough. I find rough surfaces ideal for achieving the vitality I like in a painting, and they are suitable for dry-brush effects with body colour. If you use a sketchbook, the backing must be stiff enough to allow you to work effectively.

Many different watercolour papers can be used for pen and wash

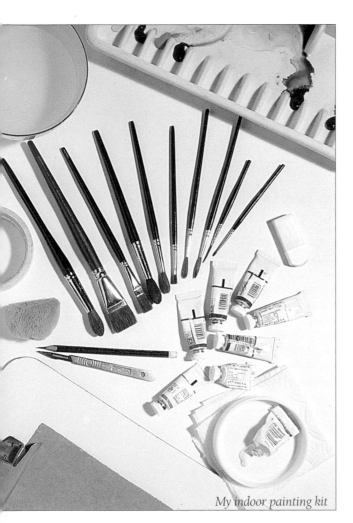

My indoor painting kit

Easels

I have two outdoor easels, including a three-legged one which stands or folds to a table – see page 11.

Sponge

This is always useful for washing out excess colour.

Absorbent paper

This is useful for mopping up spills, as well as for removing surplus colour when washing in skies.

Adhesive tape

Use this to fix paper to your drawing board.

Pencils

I use a soft pencil (B or 2B) for sketches.

Scalpel

Use this to sharpen your pencils.

Soft eraser

I prefer to use a regular soft eraser.

Masking fluid

This can be effective and time-saving, but it is really just a trick. If you do decide to use masking fluid, it can be applied with a brush or a pen (see small photograph, above left).

Choosing a pen

Ingres said it takes more than thirty years to learn to draw and about three days to learn to paint, so perhaps I had better concentrate on the drawing!

In the past, drawing was a discipline without which one could not progress. Methods, if not styles, were influenced by the means of reproduction available: for many years it was far easier to print a drawing than a photograph. As a student I well remember having to draw from the antique. Later, as a graphic designer, I had to draw accurately while taking into account the cost and suitability of the reproduction technique. Over the years, drawing tuition has become more relaxed.

Drawing with a brush requires confidence and knowledge of the subject: some of the best exponents are cartoonists. Dip pens can also give a free line, with thicks and thins and plenty of flourish if you have the courage, but may cause the occasional splodge. For a consistent line thickness, technical pens can be used but there are some drawbacks: they hate both rough paper and rough treatment. Between these extremes are all manner of drawing implements including reed pens, quills, twigs, brushes, chalks, pastels, felt pens and pencils. To gain confidence, try to find the drawing tool that suits you best. Learning to draw in line is probably easiest with a conventional pen or marker.

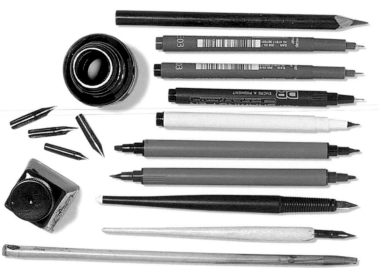

Types of pen

I have spent years looking for the ideal sketching pen, though I usually manage to spoil every one by leaving Indian ink to dry in them or letting the reservoir decay, to say nothing of damaging the nibs!

Dip pens comprise a holder and a separate nib and are used with bottled ink. Nibs are available in various sizes starting with the very small mapping pen. Good nibs have the strength and flexibility to provide bold and controlled lines. Never wash a nib: it will rust. Do not burn it in, simply doodle with it until it is manageable. Take care not to snag it on rough paper or dig it too deeply into the surface.

Fountain pens hold a considerable amount of ink. Indian ink will rot the reservoir but you can take the risk if you wash the pen out thoroughly after use.

Technical pens come in specific sizes and give a rigid, consistent line. I prefer not to use them for free sketches.

Ruling pens are similar to technical pens but even less flexible. Fine artists do use them for line work, but I suggest you leave them to the draughtsmen.

Ballpoint and fibre-tipped pens give a smooth, continuous line and can produce a free, distinctive style. They come in different line widths and a wide range of colours. It has been said that ballpoints always look like ballpoints, but even though the result does not always look like a 'pen' line some makes are very satisfactory.

Inks are available in water-soluble and waterproof formulations, in bottles and sometimes cartridges. Black and sepia are the most common shades for line work. Indian ink is the most permanent, but if left in the reservoirs of pens will rot them. Washable inks can produce very attractive effects, but let the basic watercolour dry before applying them or the ink may run. Inks made from shellac are glossy but, except for black, may fade. Acrylic inks can be used over or under watercolour and are light-fast.

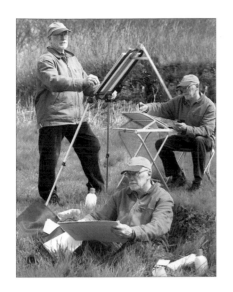

Painting outdoors

I have painted in frozen wastes, burning deserts and extremely rugged terrain, conditions which certainly concentrate the mind. There is a bit of an art to assembling an outdoor painting kit: mine is fairly minimal, with all equipment chosen for lightness and portability (see photograph, page 8). Make sure you are ready for all weather conditions so you can work in comfort without loading yourself down too much.

Working on sloping ground, or on springy turf, can be difficult if you are doing anything more than a short sketch. At times, you will need to support your paper or pad at an angle to assist the flow of paint. Sometimes I simply use the rigid back of my drawing pad. I also have two outdoor easels: a three-legged one which stands or folds to a table (left, top), and a fairly elaborate table which has a slope that is controlled by a chain and a separate seat (left, centre).

Painting indoors

If you have room, spread yourself so everything you need is at hand. I do most of my painting standing, but I may use a high stool if the job I am doing is meticulous and tiring. I have both a standing desk (left, top) and a table (left, bottom).

My desk has a drawing board which can be raised, and plenty of room for storage on the desk top and in the drawers below. The table is large because I like to have plenty of room, with a separate drawing board. I usually set out the equipment I need, and make sure I have a roll of paper towels handy to mop up any spills. I lay out a selection of brushes from the many I have collected over the years and choose the most suitable as I work.

Making marks

Left to right: dip pen, black calligraphic ink; branded art pen, black calligraphic ink; dip pen, peat brown washable ink; brush, black gouache; brush, Indian ink; technical pen, size .35mm.

Left to right: waterproof black marker pen, size .20mm; waterproof black marker pen, size .30mm; branded marker pen, size .30mm, waterproof black; branded marker pen, size .30mm, waterproof sepia; reed pen, Indian ink; technical pen, size .25mm.

Left to right (inks): sunset red; pumpkin; sepia; peat brown; black Indian ink; black drawing ink.

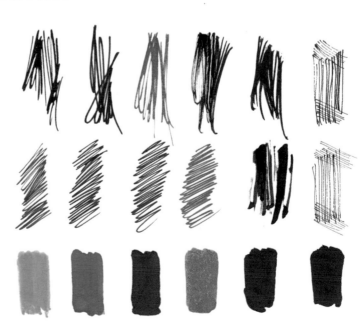

Mixing greens

Greens have worried painters for centuries. At an art society appraisal evening I attended, our expert suggested, quite rightly, that around half those present should make a special effort to study greens in order to achieve greater realism in their work.

The easiest way to proceed is to decide the look you want at the outset. Is the scene warm or cold; bright or muted; strongly or softly lit? I am frequently amazed by the power of the greens in my home county of Devon under certain conditions, just as I was in India on seeing the young shoots of rice plants. But that does not mean crude, straight-out-of-the-pot greens.

The diagram below shows how the acidity or warmth of blues and yellows can affect the colour tone of particular features, as well as the work as a whole. I have used my usual colour palette of Winsor blue (green shade), new gamboge, light red and raw sienna, plus lemon yellow. When I paint the part of the world where I live, I also use burnt sienna.

Adding other colours, or altering the balance of blue to green, can heighten the drama of the overall effect, or more realistically reflect landscapes. For comparison purposes, the examples include ultramarine, though this is not a colour I would normally use.

To mix the greens below, it is important to establish the colour effect you are looking for and to choose the most appropriate and simplest colour selection to achieve it. If ever there was a case of 'less is more', this is it!

lemon yellow
Winsor blue

new gamboge
Winsor blue

lemon yellow
Winsor blue

new gamboge
Winsor blue

new gamboge
ultramarine

raw sienna
Winsor blue

new gamboge
burnt sienna
Winsor blue

new gamboge
Winsor blue
alizarin crimson

right: St. Michael's, Prague
This picture is particularly green. It was summer in Prague, and the hillside, foreground and background trees were in green tones intended to achieve an overall summery effect with recession. The pen work picks out detail, but not too strongly.

size: 260 x 180mm (10¼ x 7in)

Three yellows, two blues

This selection of greens is made up from only five colours. I normally use Winsor blue, so have shown its effects with lemon yellow, new gamboge and raw sienna, gradually increasing the amount of blue in each case. I have also shown ultramarine with new gamboge, my preferred yellow for mixing greens.

Trial and error can tempt you to into all manner of alternatives, but these examples show the effects of varying the proportions of the colours and water in the mix. You must also consider the type of paper: variations can be considerable and a few dummy runs should ensure that you are forewarned.

lemon yellow/Winsor blue *new gamboge/Winsor blue* *raw sienna/Winsor blue* *new gamboge/ultramarine*

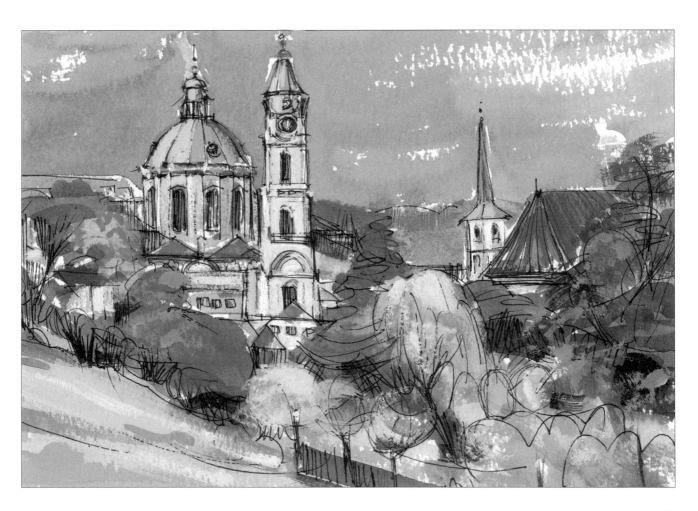

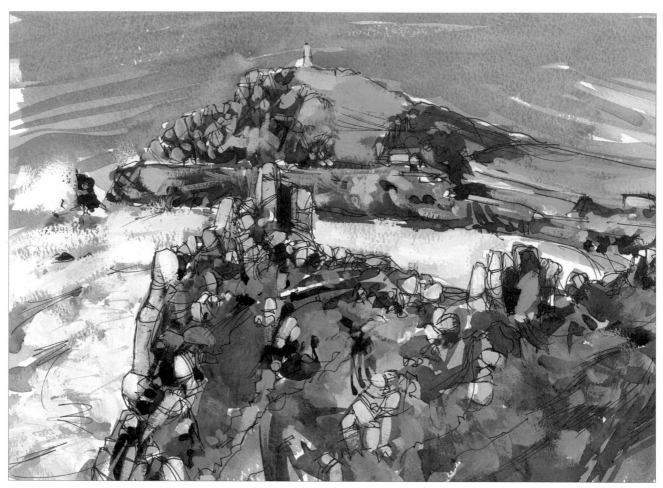

Cape Cornwall

*This promontory just north-east of Land's End is a
favourite of mine. To obtain a good viewpoint, I staggered
up a steep hill to a jumble of rugged rocks and tucked
myself into a nook at the top. I had two problems: my fear
of heights, and my fear of heights on a cliff edge in a stiff
breeze! It may not surprise you to learn that the sketch
was done in record time, with much of the final work done
in greater comfort and less-precarious circumstances.
I was pleased with the effect, a boisterous, sunny seascape
which captures the elements, the state of the sea, and the
geology of the place.*

size: 330 x 260mm (13 x 10¼ in)

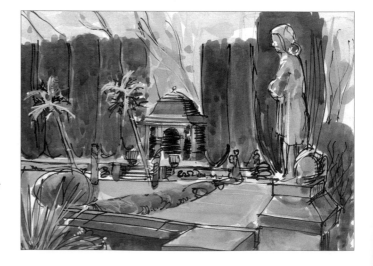

Italian Garden, Tapeley House, Devon

*Drawn in a small sketchbook on a quiet, sunny day, this
painting shows the statuary, formal layout and peaceful
confines of the garden in an historic house. Its air of
tranquillity belies the fact that, within earshot, there was a
demonstration of jousting.*

size: 210 x 145mm (8¼ x 5¾ in)

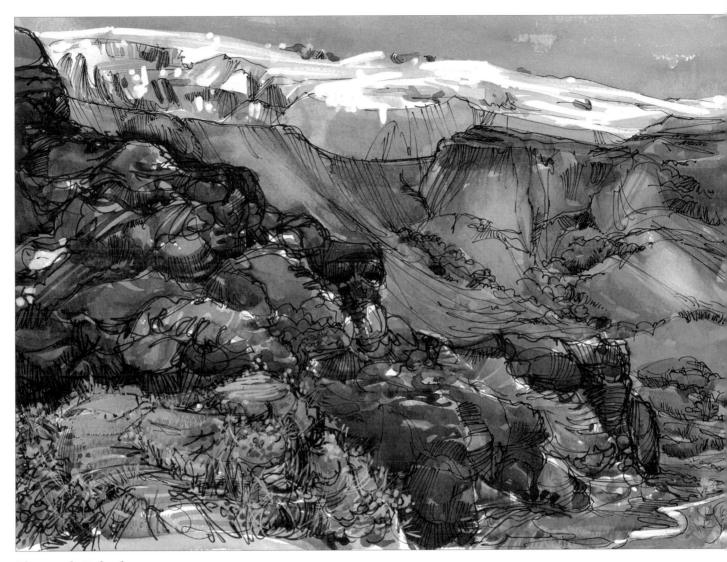

Thorsmork, Iceland

I had decided to paint a glacier. In this particular valley there were three, towering above the immense expanse of glacial plain, sometimes with scruffy shrubbery and sometimes not, often cut by rivers which we had to traverse in jeeps. I could see all three: one to the left; one to the right and my choice, straight ahead. I climbed the cliffs, hoping that at any moment I would have a magnificent view of the glacier, but the higher I climbed, the more ridges appeared in front of me to obscure it. I gave up and turned round, to discover this view. It is an interesting point that, when you are retracing your steps along the same path, the reverse view and the lighting are invariably completely different from what you saw on the way out.

There was so much to paint here, and such a steep drop! In the end, I washed in the main areas – foreground and near cliffs – and indicated both the glacier and the valley down to the winding river. Quite a lot was done on the spot, but I had to return to the vehicle to avoid being left behind. Later, I intensified the recession and drew in the effect of a sloping landscape with a glacier peeping over the top.

Size: 280 x 213mm (11 x 8¼ in)

Washes

I believe that, if you can paint a perfect wash, you are halfway to a recognisable watercolour painting. The beautifully-controlled washes of Sir Russell Flint almost make me want to give up. Fortunately, this is not the only way to paint, and the following basic points may help. If you are using paper lighter than 140lbs (300gsm) you will need to stretch the sheet or it will cockle, preventing the paint from flowing and from drying evenly. Even when using heavy paper you should take care. The more water you use, the lighter the shade and the faster the paint will flow. It takes practice to judge the amount of water needed for a very strong mix and to know how the paint will dry on a particular paper.

The strength of colour can be varied through a wash by diluting or increasing the pigment content. Additional washes can be laid over a wash, sometimes when it is still wet. One of the most important points about washes is to mix the right amount of paint for the area to be covered. This may sound obvious, but if you get it wrong, you may run out at a crucial moment. Use a large container and mix more than you think you will need. Have plenty of clean water to hand, both for diluting the mix and for ensuring that your brushes are always clean.

My own style is to lay mixed washes over general areas first to establish a colour look. This means that later applications of colour (dabs rather than new washes) can be used to add detail. Though we shall also be considering added pen detail, this should not diminish the desire for correct under-painting.

Watercolours are primarily concerned with transparent colour: one colour laid over another. The number of additional applications possible before it all turns muddy depends on the weight of colour, the weight and type of paper and the drying time. There are times when you will want to lift off colour for a highlight, and there are many ways to do it. Ideally, you should leave a white area or apply masking fluid to keep the spot clear of paint. Sponges and tissues can also be used. My own method is to apply body colour – gouache – for over-painting. As a general exercise, pour a little water into a mixing palette. Add colour from your paintbox pan or tube and mix thoroughly. Next, apply the paint in smooth strokes across the paper with a large round or flat brush, overlapping the first strip slightly to avoid a white gap between the two. Try again, this time darkening the colour mix for the lower part by adding more pigment. When you come to try this in a painting you will need to know if you want to return to the original colour, which you have just lost by increasing its strength!

Washes are a skilled operation, and practice makes perfect, if that is what you want. I prefer a greater element of self-expression. If all other considerations of a painting – composition, colour balance and good draughtsmanship – are right, superb washes are the icing on the cake.

a) Light wash of alizarin crimson, strengthening as it descends before merging into a lighter mauve wash.

b) Winsor blue wash; light red added to produce grey; mix strengthened to increase depth.

c) Gamboge yellow wash ; light red added to gamboge yellow. Note how the red creeps upwards into the yellow, which is useful for painting distant trees.

d) Dry brush effect with light Winsor blue and darker alizarin crimson washes. Can be useful for fleeting clouds in windy skies or ripples on water.

Wash effects

The examples on the left show how colour might be introduced at the base wash stage. They were laid on rough paper, which sometimes has a mind of its own and does not always give a flat, pristine finish, but this can give a picture character!

The alternative is to over-paint, i.e. apply one wash over another. Results will depend on factors including the amount of water used, whether the base wash is still wet, and whether the colours used are compatible e.g. blue used over yellow will produce green. The examples below show some of the possible results.

a) New gamboge overpainted with raw sienna.

b) Alizarin crimson overpainted with Winsor blue

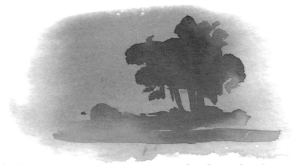

c) Wet-on-wet mauve tint overpainted with purple. The variations in tone of the darker shade result from a combination of wet paper and adding water.

d) Raw sienna overpainted with two brown shades which were allowed to run into each other.

Darker tones

I never use black when using watercolours. However, we all need dark effects from time to time, and in varying intensities. What I refer to as a real blackish grey can be mixed using Winsor blue and light red; the examples below show how to vary this base mix to produce a useful range of darker tones.

Winsor blue and light red produce a blackish grey...

increased Winsor blue, perhaps for a dark sky...

added alizarin crimson, useful for a sunset ...

added raw sienna, ideal for an autumnal shade in trees.

17

Pen and wash technique

These pages are intended as rough guides to increasing definition. The washes establish the feel of the painting, then a simple, free line is applied to tighten up the image, depending on the detail you require.

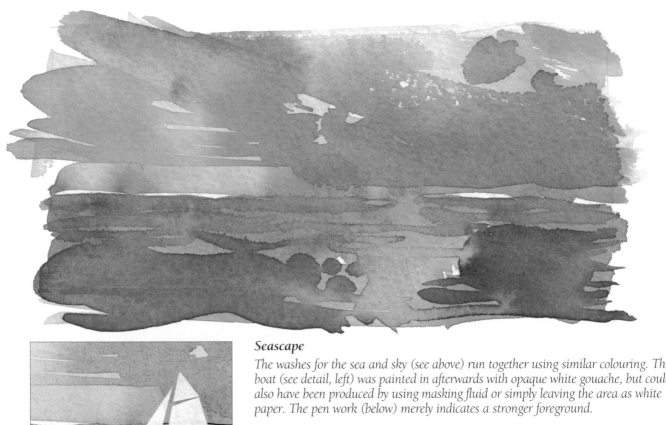

Seascape

The washes for the sea and sky (see above) run together using similar colouring. The boat (see detail, left) was painted in afterwards with opaque white gouache, but could also have been produced by using masking fluid or simply leaving the area as white paper. The pen work (below) merely indicates a stronger foreground.

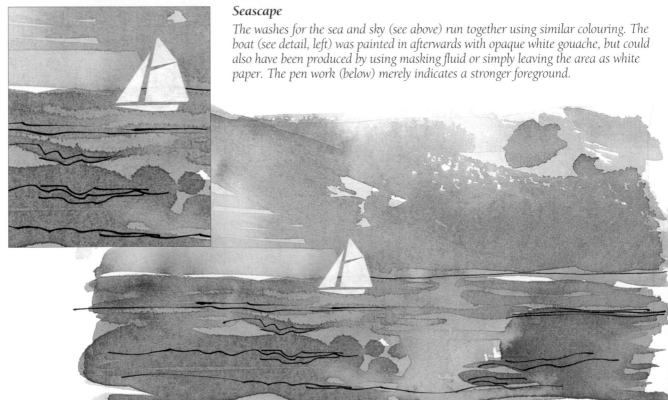

Autumnal evening sky

simple wash

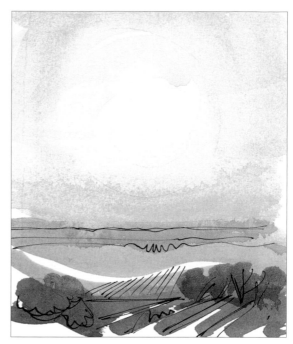

lines added

Church among trees

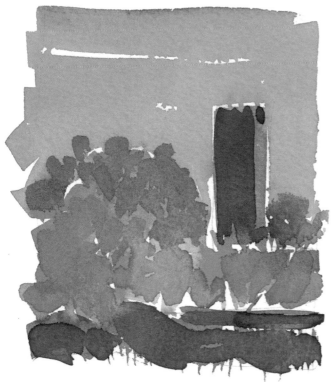

simple wash

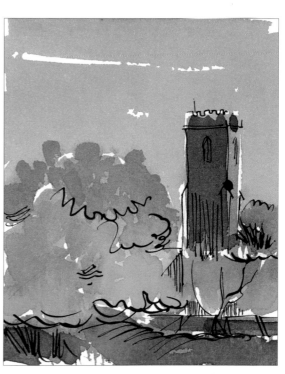

lines added

Adding lines

The addition of line to wash can produce immediate drama and detail. The technique is not just for sketches which will be worked on later: it can result in fully-resolved works of art.

I am sure you will want to develop your watercolour technique to achieve those wonderful flowing, clear washes which so eloquently define mood and content. This can take years of practice, but while you are working to improve your painting skills, your drawing skills can also be developed. After all, you probably first learned *drawing*, using chalk or coloured crayon.

Observing detail and setting it down accurately is the key to success with most paintings. You will probably want to sketch in compositional shapes, so adding a few stronger, more permanent lines will not be too great a step.

There is a strong emphasis on drawing skills because the success of the final result will depend upon it. The standard of drawing we are able to achieve improves in direct proportion to our understanding of the subject. Art teachers have told me that the ability to draw is a skill which cannot be taught, but I believe this is absolutely untrue: it is all a question of degree. Let's face it, none of us is really expecting to emulate Michelangelo. Even those of us who are not experts possess the ability to capture the essence of a subject in one way or another.

Primarily we need to *observe* and *record* the images that are seen, considering the balance of one feature against another, the changes in lighting, the recession from one level to another. Pen and wash is usually represented by a dark impression over, or under, watercolour washes. The line will tend to be solid, with no greys; the tones will be part of the colour wash. Lines can be drawn freely with a brush, or with

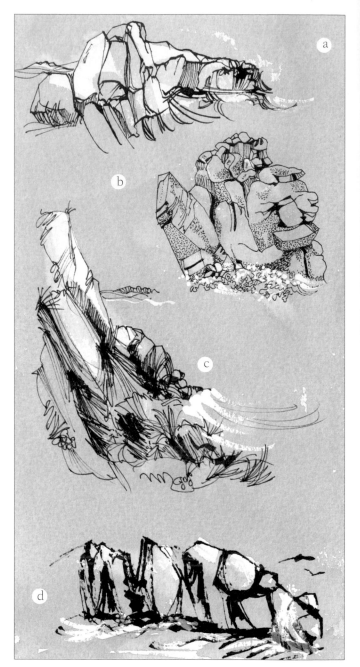

Examples of line work, above:

a) *was drawn with a dip pen and black washable ink, giving a free, flowing line.*
b) *was drawn with a technical pen, which gives a precise line of a consistent width and allows accurate, though not rapid, drawing.*
c) *was drawn in black marker pen, which gives a line of consistent width and allows you to draw freely without risk of smudging. Over-drawing can produce a stronger effect.*
d) *is in reed pen; a piece of split cane with a reservoir. It is far more difficult to control, but dramatic effects can be achieved.*

I spoke of 'no greys', but there will be occasions when you will feel a need for more weight in the drawing: cross-hatching or stipple effects, even some solid areas, to give your work a lift. In this book there are examples of lines carried out with many different types of pen. Remember that coloured inks can produce some extremely interesting effects: there is no need to limit your line to black.

Examples of line work, right:

a) was drawn with a coloured marker pen, which is ideal to carry around ready for a sketching opportunity.
b) was drawn with a brush and black ink, showing how wonderful linear effects can be achieved with a brush if you have the confidence to draw with immediacy.
c) was drawn with a dip pen using peat brown ink.
d) was drawn with an art pen. These come in various nib widths and have a cartridge or a plunger, making them ideal for outdoor work.

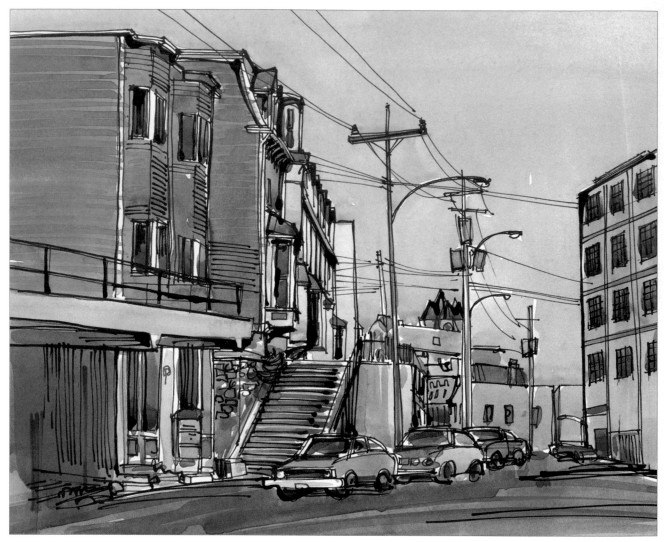

St. Johns, Newfoundland

This picture shows a busy street scene. Its attraction for me was the style and colour of the buildings, and the untidy and rickety telegraph poles. Quick colour washes, and a few pen lines to formalise the buildings and cars, were all that was required to capture the atmosphere of this highly-individual city. Making far more of the angles and projections of the buildings would have been an option, but I decided against it.

size: 240 x 200mm (9½ x 7¾ in)

Silves, Portugal

My sketch of Silves was more of a compositional challenge. The castle is dominant, but I wanted to include more detail in the picture. The turret on the left led to a wall and then down to an archway, with a grassy bank suggesting the slope and height of the bank. Beyond is an idyllic pattern of hills and plantations. The colour washes are vague and uncomplicated and the pen detail, in brown ink, just adequate to hold the picture together.

size: 180 x 260mm x (7 x 10¼ in)

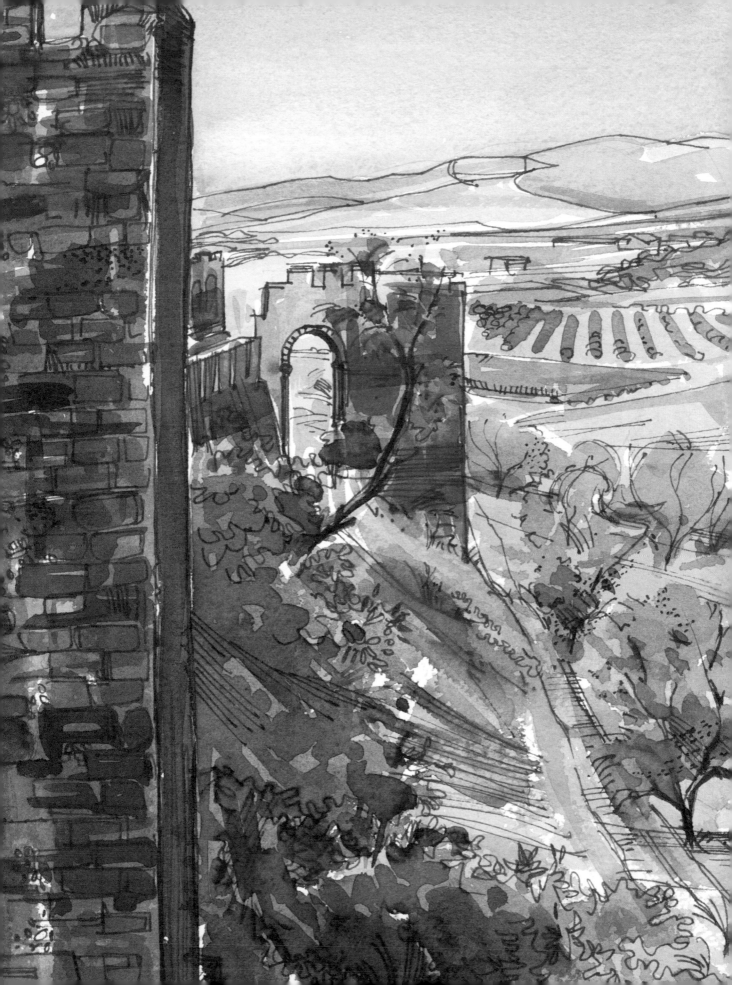

Simple landscape

For this type of subject try to decide the 'look' of the picture. The weather conditions, and the angle of the sun, are important elements that make the subject-matter specific to a time and place.

 Here, at the Valley of the Rocks in Devon, England, I was impressed by the strong sky silhouetting the rugged outcrops. In complete contrast, in the shelter of the hills, there is a peaceful, grassy cricket pitch. The cliffs behind the hills drop almost sheer into the sea, and the overall effect is a strong image, with a slightly menacing sky and low sun angle.

You will need

Watercolour paper 140lb (300gsm)

B pencil

Round brushes:
 Nos.14, 12, 10, 8 and 4

Flat wash brushes:
 25mm (1in); 13mm (½ in)

Watercolour paints

White gouache paint

Eraser

Dip pen and medium nib

Indian ink

Absorbent paper

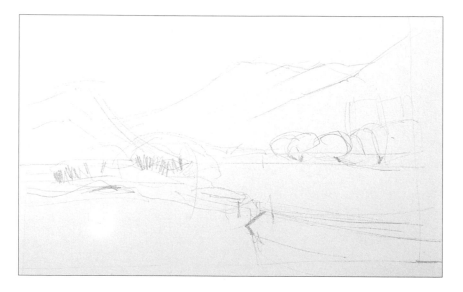

1. Using a B pencil, put in a few preliminary marks to delineate the basic landscape.

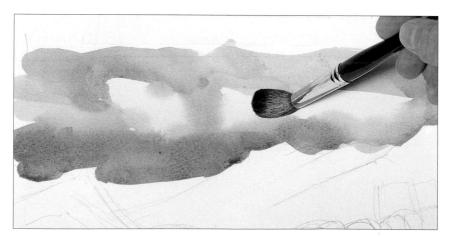

2. Using a No.12 round brush, put a wash of very dilute raw sienna in the centre of the sky area. Working quickly wet-into-wet, add darker tones using a mix of Winsor blue, alizarin crimson and a touch of raw umber. Rinse the brush and use it to blend in any harsh edges.

3. Using a piece of absorbent paper, rub out some of the strong blue in the central area of sky.

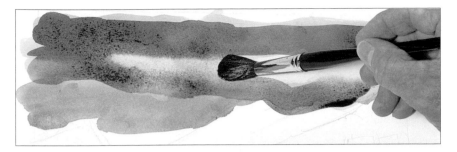

4. Still with the No.12 round brush, build up some slightly darker blue tones in the sky, then rinse the brush and blend in the edges with the lighter area.

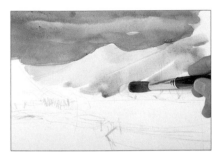

5. Still with the same brush, put in a small triangle of pale blue for the sea and some green for the distant hills.

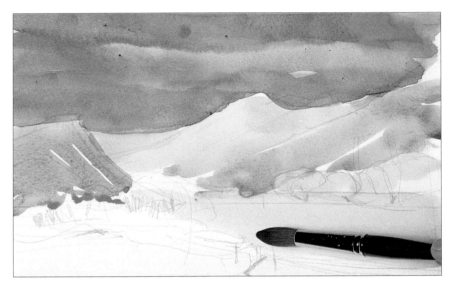

6. Using a mix of raw sienna and burnt umber with a little Winsor blue added, paint in the hill on the left. Dilute the same wash and put in the shape of the field on the right.

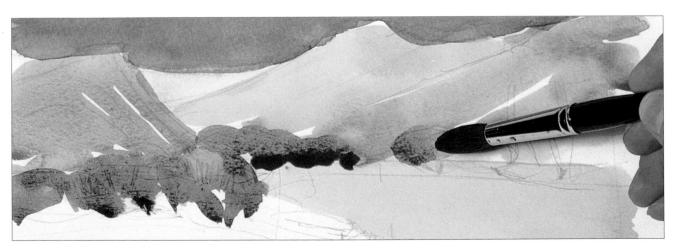

7. Change to a green shade mixed from Winsor blue and raw umber and put in the background for the hedgerows.

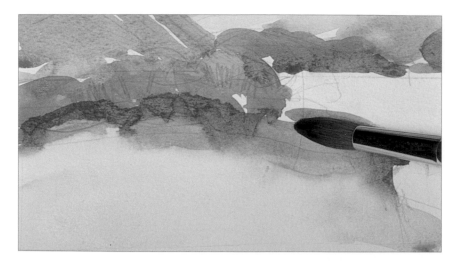

8. Dilute the green mix and lay down a pale wash for the left foreground.

9. Using a 25mm (1in) flat brush, add darker blue to the sky in patches and sweeps. Add touches of alizarin crimson and raw sienna to redden the mix and suggest the glow of the dying sun.

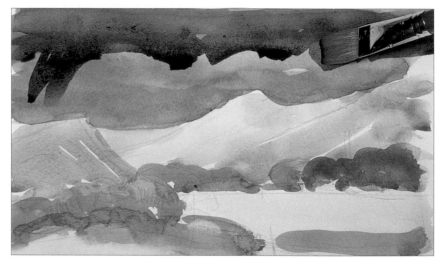

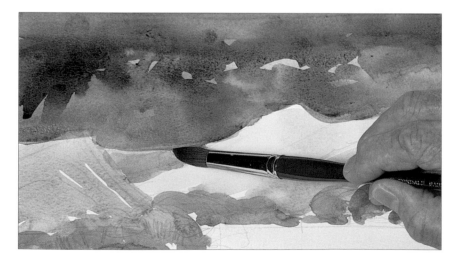

11. With the same blue tones that were used for the sky, but diluted to a weak wash, put in the background for the stone wall in the right foreground.

10. Change to a No.14 round brush and build up more dark tones in the sky, then strengthen the small triangle which represents the sea.

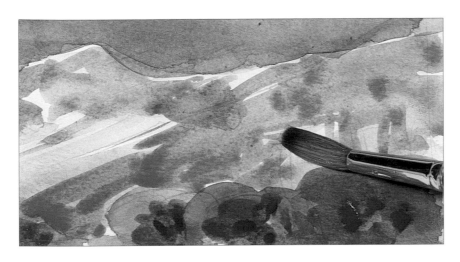

12. Mix a range of browns using raw sienna for the light tones and gamboge for a more intense effect. With the No.14 brush, use these browns, and the greens already in the palette, to paint in landscape features in the middle distance, including the rocky outcrops and a suggestion of trees.

13. Using a No.10 round brush and a mix made from Winsor blue and raw sienna with a little burnt sienna, put in the hill in the middle distance. Add a little more detail to the hedgerows, including the trunks of the trees. Add raw sienna and new gamboge to make the mix a bit greener, dilute slightly and begin to build up more detail.

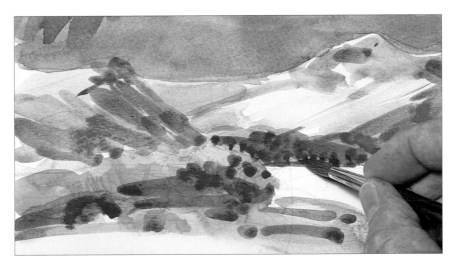

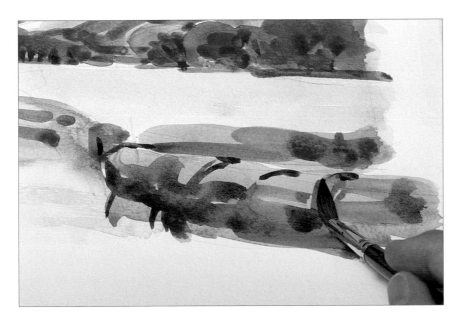

14. Using a smaller brush – a No.8 is ideal – and the various tones of brown which you should by now find lurking in the bottom of your palette, 'draw' in details of the stones in the wall in the foreground. Allow to dry, then erase the original pencil guide lines before applying pen.

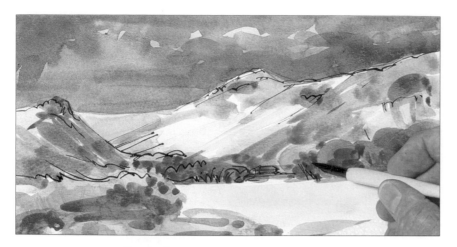

15. Using a dip pen with a medium-width nib and Indian ink, partly outline the hills and add some detail, varying the marks between straight lines and squiggles to make sure the effect is not too 'regimented'.

16. Working forward and from left to right (or from right to left if you are left-handed) to avoid smudging your work, sharpen up details by bringing out features, drawing in the hedgerow, house, trough and wall.

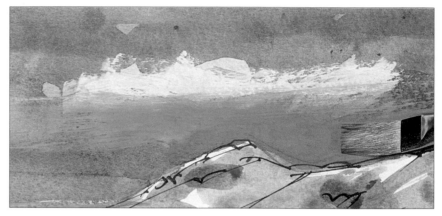

17. In a separate palette, tone down white gouache with raw sienna, a little lemon yellow and a touch of new gamboge. With a dry, flat 13mm (½ in) brush, add a light area to the centre of the sky. Transfer some of the white mix to your main palette, add a little Winsor blue and a touch of Indian red, then sweep this lighter sky tone across the lower half of the sky.

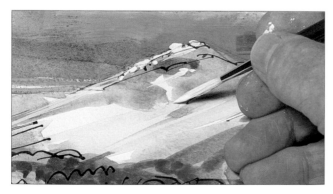

18. Using a No.4 brush, and adding more white gouache to the mix, build up the detail on the rugged hillside.

19. Work over the whole painting to put in the final details, then add the last touches to the wall.

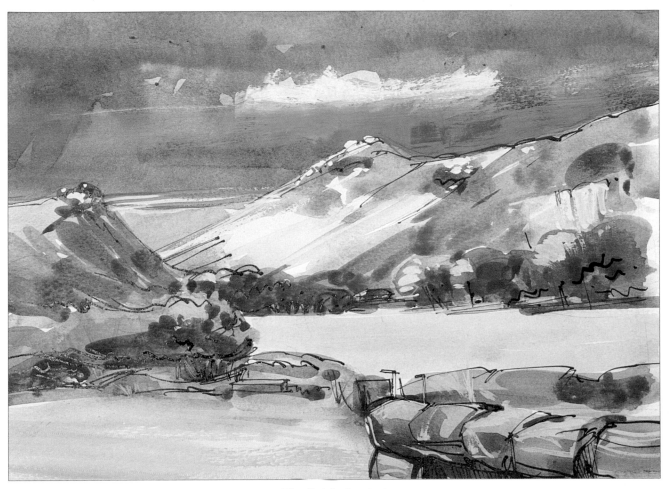

The finished painting

You will see that this is loosely drawn and painted. I work in this way when out of doors because, with changeable weather and lighting, it is important to establish the initial idea of the painting. This work may take half-an-hour to an hour, as it has to be executed quickly. You can always do more work when you arrive home, but this tends to negate the spontaneity of the outdoor sketch.

If I were to paint the same scene in my studio, the detail would be more precise and the chances are that it would take a day or more to complete – and look quite different.

size: 280 x 200mm (11 x 7¾ in)

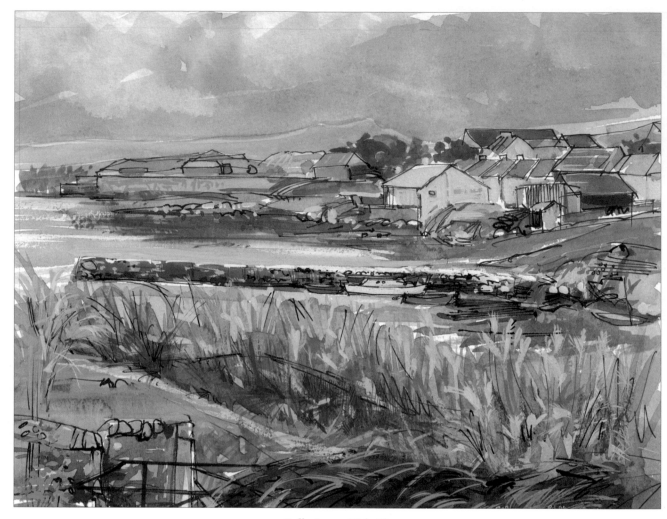

Coll, Inner Hebrides

*The islands of the Inner Hebrides, off the west coast of Scotland, are
serene (on a good day) and cry out to be painted. There is a warmth
to this picture which reflects the temperate climate, white sands and
total peace of the island. The washes are simple and the line work, in
brown ink, just enough to identify buildings, plants and boats.*

*This picture was done when I had returned home, from notes and
photographic references. This was for two reasons: firstly, that I was
on a painting holiday based on a sailing vessel, which did not offer
ideal conditions for setting out all my gear. The second reason was
that, when I went ashore, I managed to leave all my equipment
except for a pen and ink aboard!*

size: 240 x 180mm (9½ x 7in)

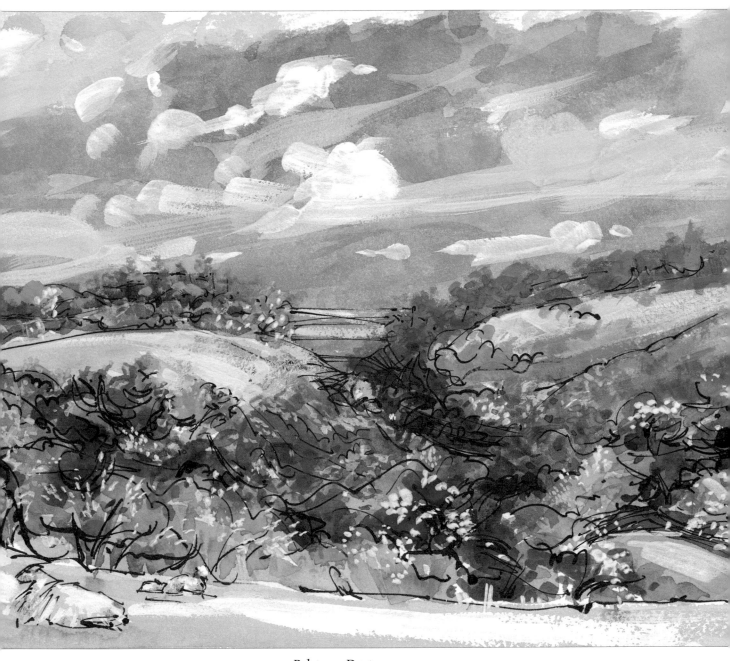

Belstone, Dartmoor

This picture was done on a blustery evening, looking down into a Dartmoor valley that dropped steeply away to a river. The painting is simple with a lot of bold gouache overpainting, particularly in the foreground and sky areas. It is a quick sketch which captures the time and conditions of the day. Almost every part of Dartmoor is unique and it is important to identify, where possible, the season and weather conditions. There is no real attempt to draw sheep or trees accurately: they are just part of the general scene.

size: 280 x 220mm (11 x 8½ in)

Seascape

The wild water and rugged coastline of the Hartland peninsula in Devon is the inspiration for this composition. I made sketches looking steeply downwards on the scene, so the painting starts just below the horizon. With this painting, as I come to put in some of the detail, I shall be changing to a thinner brush and using it to 'draw' in the detail.

1. Using a B pencil, put in a few preliminary marks to delineate the contours of the land and the main rock formations.

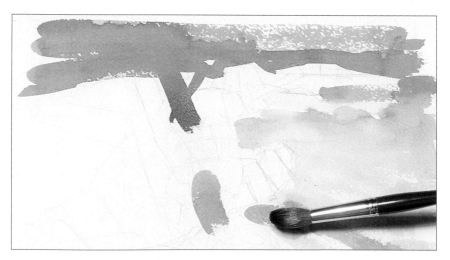

2. With the No.14 brush, wash in the lightest areas (the sea) using a mix of Winsor blue (green shade) with a little lemon yellow and alizarin crimson. To create a very pale wash for some areas, simply wet the brush with water to dilute the residual colour without adding more.

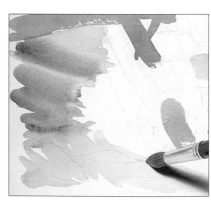

3. Put in the green base wash for the cliffs using new gamboge with a touch of Winsor blue, adding a little raw umber to intensify the tone towards the foreground. Brighten the mix with a touch of lemon yellow for the foreground.

4. Change to a No.6 round brush and paint in the light tones for the cliffs using raw sienna with a touch of each of light red and Winsor blue.

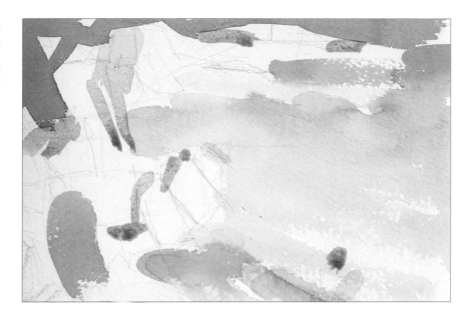

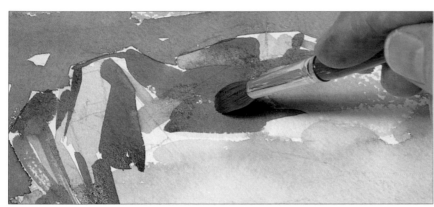

5. With the same brush, mix a stronger shade of blue using Winsor blue, raw sienna and alizarin crimson and paint in the dark tones of the rocks. Lighten the mix with a little raw sienna and water to vary the tones.

6. Deepen the mix with a touch of alizarin crimson and begin to paint in the deeper shadow tones of the rocks.

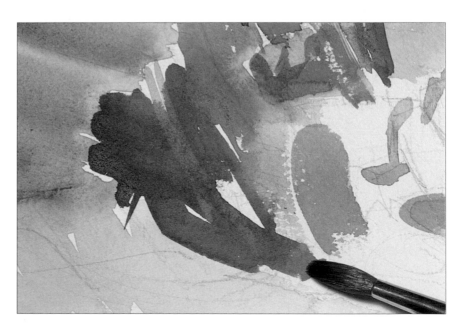

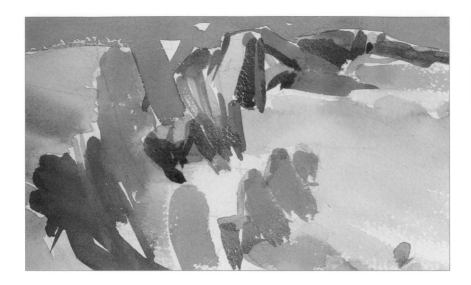

7. Add some light red to the mix to vary the tones and paint in more rocks.

8. Mix up some new gamboge and add some lighter tones right across the foreground, over the green wash which is already there. Add in a little raw sienna to deepen the mix and work across the whole area.

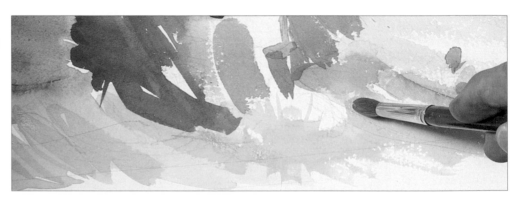

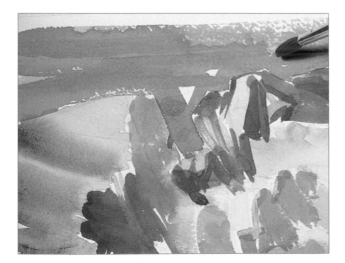

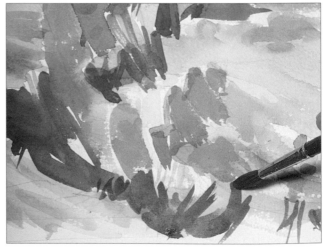

9. Mix up raw sienna and burnt umber and put some tone into the sea, varying the concentration of water in the mix and using sweeping strokes to mimic the movement of the waves.

10. Put some tones into the area of green cliff and the foreground using a mix of raw sienna and light red, adding Winsor blue to the same mix to make a deeper green.

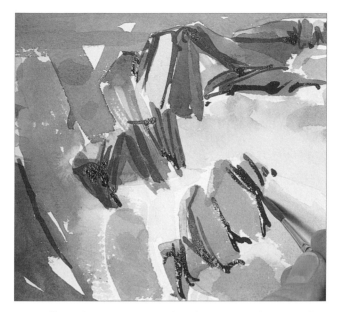

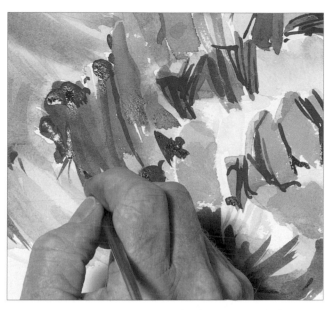

11. Allow the painting to dry then erase the pencil lines. Using a smaller brush – a No.4 is ideal – and dark tones made from a strong mix of Winsor blue and raw umber with a touch of alizarin crimson, paint in the detail of the rocks.

12. Varying the tones around a base mix of alizarin crimson, Winsor blue and burnt umber, put in some deeper tones in the nearest outcrop of rocks.

13. Allow the painting to dry. Using a dip pen with a medium-width nib, add lines to sharpen up the contours of the rocks.

14. Using the same pen and ink, add in more details, putting in squiggles and flourishes. Try not to overload your pen with ink, but do not worry if there is the occasional small blob as this just adds character to your painting – simply blot off the excess and continue.

15. Make up a strong mix of dark burgundy brown using Winsor blue, alizarin crimson and raw umber. Load the paint on the tip of a dry, flat 10mm (⅜ in) brush and stroke it across some areas of your painting to add texture.

16. Tone down some white gouache with a little gamboge yellow and sweep it across the green cliff to add highlights.

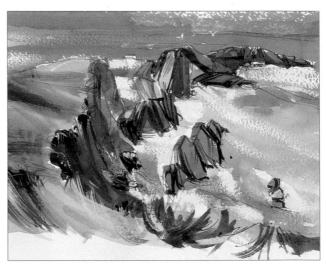

17. Still with the same brush, highlight the waves using pure white gouache. Change to a No.1 brush to refine the painting where necessary. Paint in a pair of seagulls as a finishing touch.

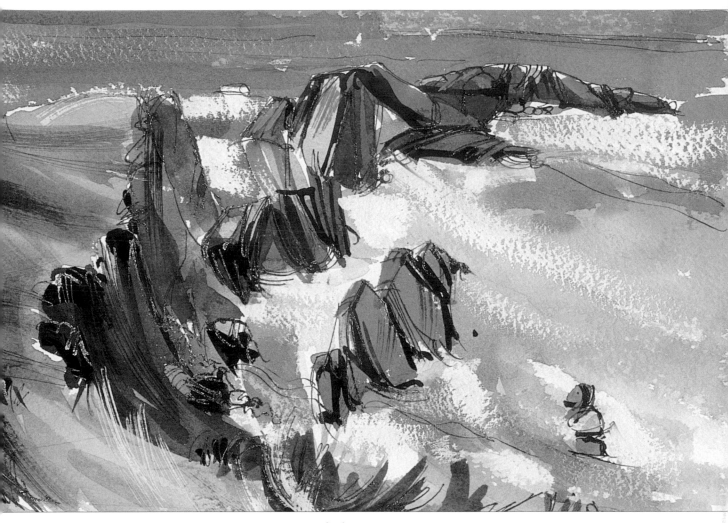

Finished painting

To succeed on the spot, in any medium, requires courage and focus:
you cannot do it all. Your picture should capture the moment, whatever
it is. The sea here changes constantly with the effects of tide and
weather, and the sun is here one minute, gone the next. You could be
sunburned or blown off the cliff (perhaps both) which is all the more
reason to adopt a bold, quick style which captures what you so admired
about the view in the first place.
I felt that the movement of sea against firm but eroded rocks,
contrasting with the headland, summed up the beauty of Hartland. The
result is a powerful and free representation of a weather-worn and sea-
battered coastline, each wave creating a unique seascape.
I have also painted this scene, and others of the same coastline, in oils.

size: 280 x 190mm (11 x 7½ in)

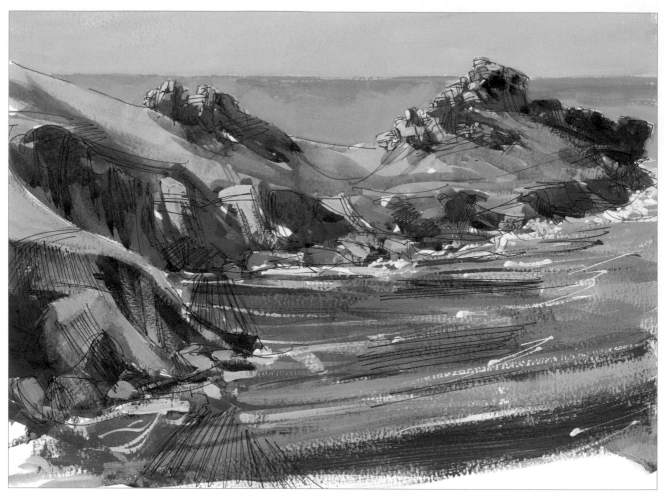

Gurnard's Head, Zennor, Cornwall

*The sun was slowly sinking in the west, making the cliffs and
sea darker by the minute. I needed to do a rapid sketch,
emphasising the sweep of the land and the flow of the sea, with
pen and body-colour detail to hold it together. While the
washes were drying, I turned my seat round to check the
opposite view. It was completely different, with granite stacks
and direct erosion from the Atlantic, and completely sunlit —
so I painted two pictures at the same time!*

size: 340 x 250mm (13½ x 9¾ in)

Portimão, Portugal

*This part of Portugal has the most wonderful coves, with
extraordinary colours in the sea and cliffs. I like the
composition of this sketch: it shows the clifftop hotel and a
secluded beach but I am not sure how you reach one from the
other. This time, I worked from notes and a photograph so the
picture has a cleaner, more precisely-drawn appearance. There
is just sufficient pen work to illustrate the cliff formations.
Sometimes paintings drawn from photographs have a stilted
look: I hope this does not.*

size: 180 x 260mm (7 x 10¼ in)

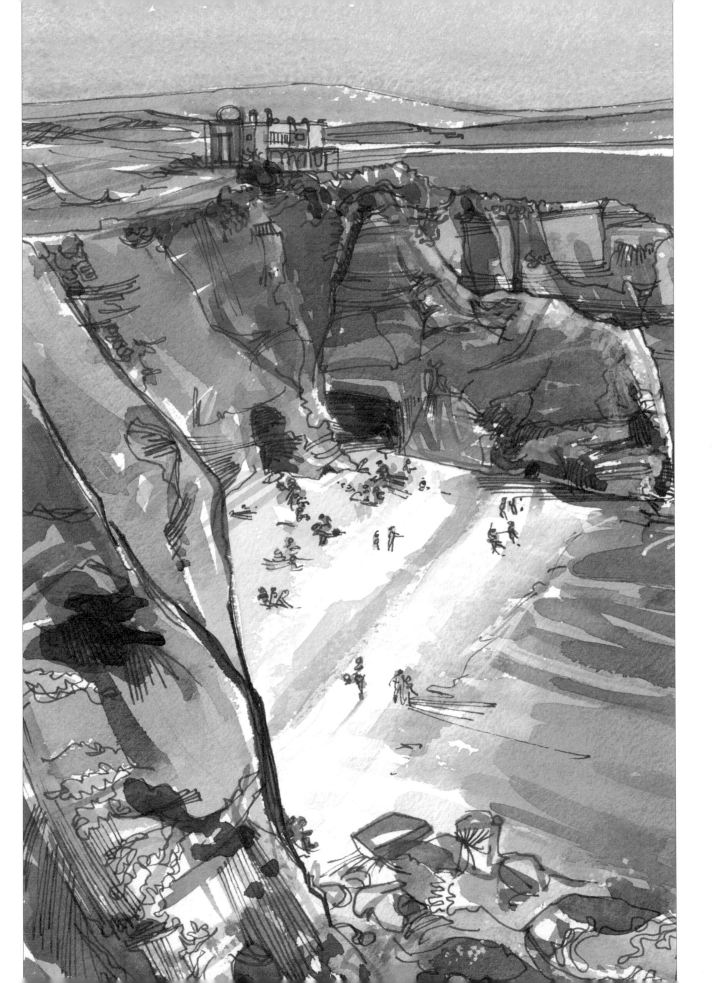

Village scene

Painting buildings requires a different approach. If the building is a focal point, it should appear stable, substantial and balanced. Location should also be considered; maybe a feature in an open landscape (perhaps a stately home); snuggled among other buildings, or virtually hidden (perhaps a poacher's cottage). These factors dictate the atmosphere of the picture, especially its lighting. You should also consider your own drawing skills: do not attempt the impossible. This painting is of a village church, hidden behind other buildings and huge trees. The church must be emphasised by making sure that it is framed by the trees and houses, and is well lit.

You will need

Watercolour paper 140lb (300gsm)
Soft pencil (B or 2B)
Round brushes:
 Nos. 14, 10, 4 and 1
Fine marker pen
Watercolour paints
White gouache paint
Soft eraser
Absorbent paper

1. Using a soft pencil, make an outline sketch of the scene. If the line shows when the painting is complete, it can be erased.

2. With a No.14 round brush and a mix of Winsor blue with a little raw sienna added to tone it down, put in a wash for the sky. Change to a mix of burnt umber and Winsor blue and put in the background of the trees, working wet-in-wet and adding a little gamboge yellow in places to vary the tones.

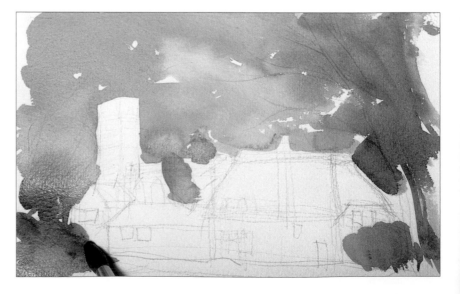

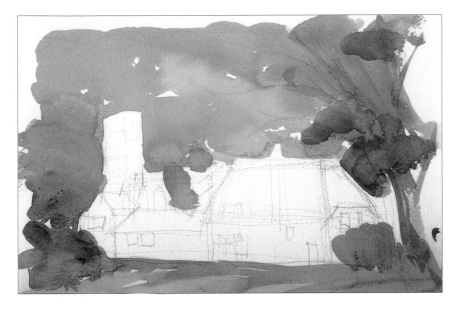

3. Continue across the bottom of the picture to frame the building detail, and put in a wash using the same basic mix as before. With a slightly deeper concentration of mix put in more detail on the trees.

4. Change to a No.10 brush and put in the thatched roof using burnt umber mixed with a little raw sienna. Put in the gable end wall with raw sienna, then add a little light red to the mix and add the chimney. If more detail is required, it can be added with pen lines later.

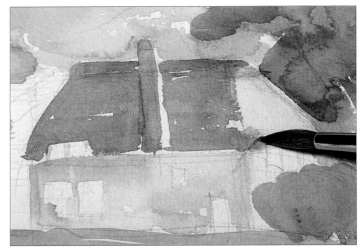

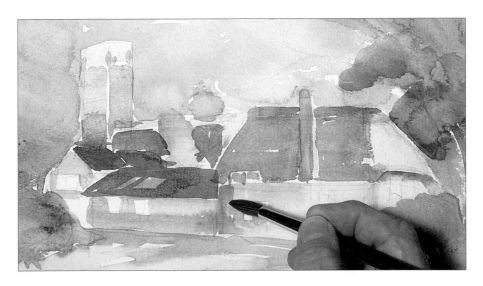

5. Block in the rest of the buildings, varying the tones of the washes appropriately. The more blocking-in of tonal areas at this stage, the better, as it is easier to see the forming of the whole picture.

6. Using a No.10 round brush add detail all over the painting, varying the tones appropriately. Change to a No.4 round brush and, using a strong mix of Winsor blue and burnt umber, draw in the branches of the trees. Still with the same brush and a brown mix, add details to the architecture.

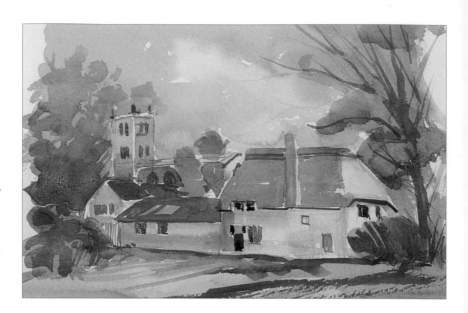

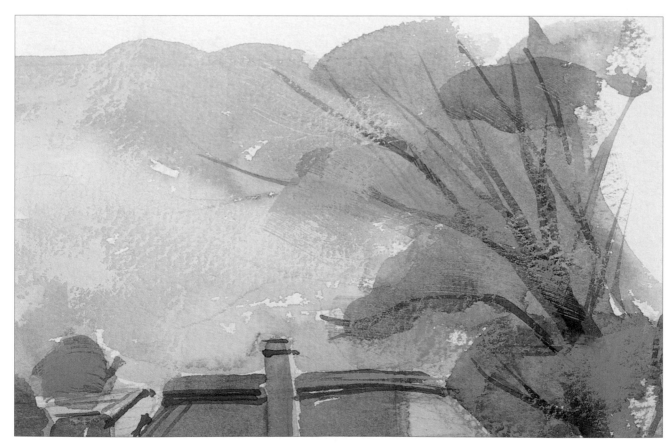

7. Mix up some white gouache with sky tones and use to soften the sky and suggest cloud. Add a little raw sienna to the mix and put in some patches across the foliage.

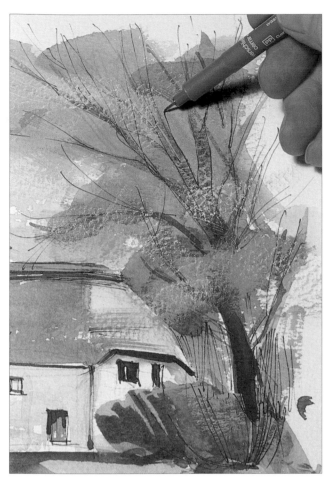

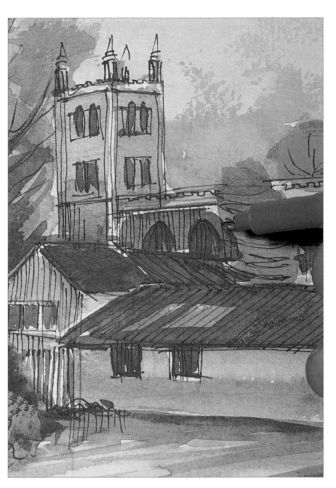

8. Using a fine line marker pen, draw in the fine network of branches on the tree.

9. With the same pen, put in the fine detail of the architecture on the church and the thatched house.

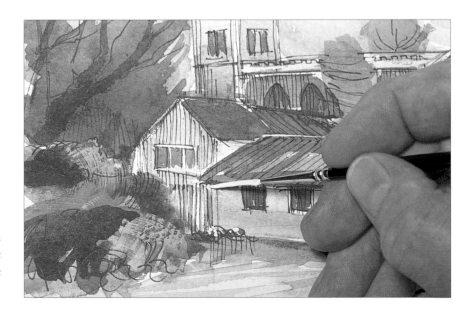

10. With a No.1 brush, put in some delicate white gouache highlights to add definition to the whole painting.

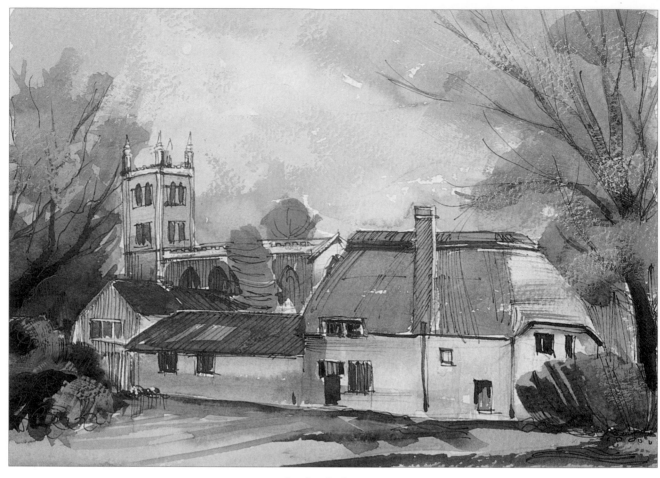

The finished picture

The result is quite effective, with the church nestling among its surrounding trees and buildings. As a demonstration picture, this is more freely painted than usual: I was more interested in capturing the atmosphere than every tile, twig or window pane.

size: 280 x 200mm (11 x 7¾ in)

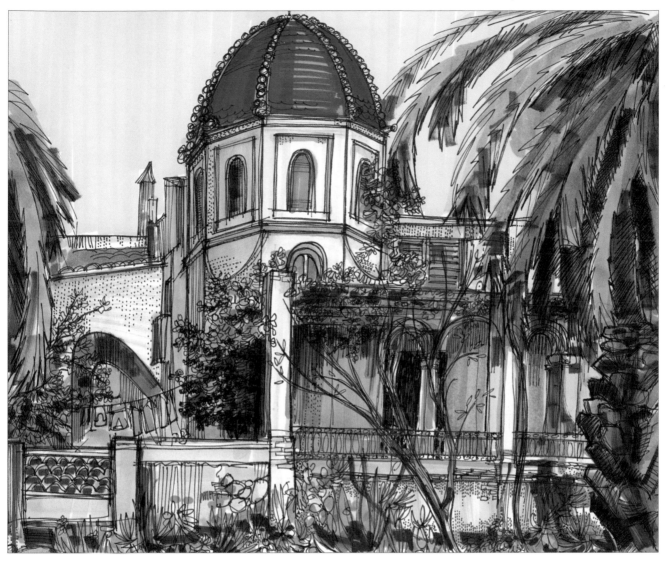

Altea, Spain

*The subject of this picture, painted from a railway platform,
demanded more accurate planning and attention to detail.
The colourful dome of the Moorish building is the obvious
attraction; the building itself is complicated, irregular and
fascinating in its styling. I have tried to concentrate on the general
atmosphere, rather than architectural niceties. Note the intensity of
the colour used for the dome and the warmth of the shadows
elsewhere. There is a great deal of foliage which, apart from creating
a setting, is of less importance than the building.*

size: 240 x 200mm (9½ x 7¾ in)

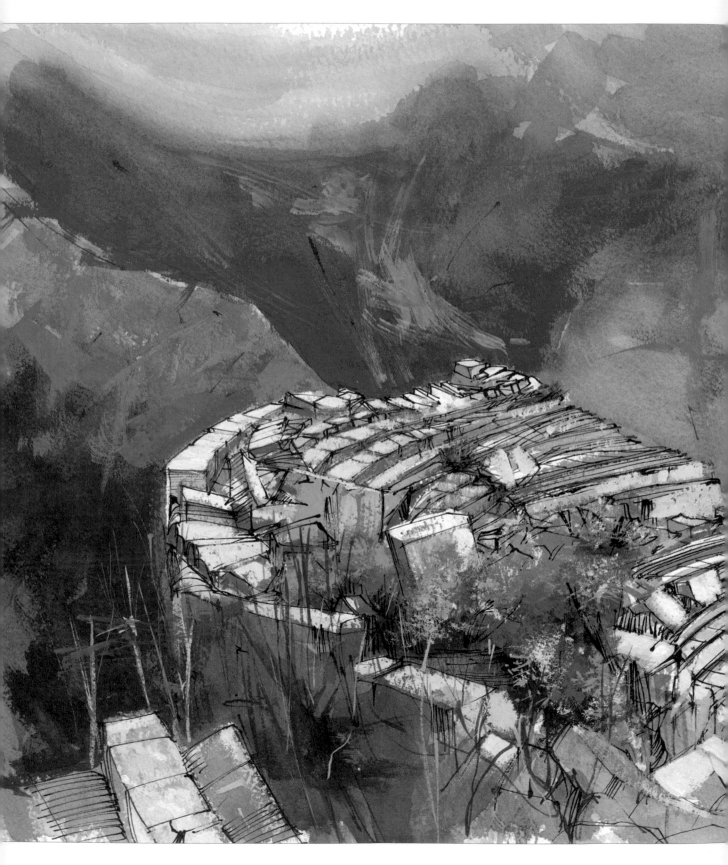

Conclusion

A picture is successful if it achieves the anticipated response from yourself and others. Developing skill can improve the academic standard, but it is what you feel about it that matters.

Give yourself the best chance by making sure you use good-quality materials. Nothing limits your skills more than using a brush with no spring, or paper unsuitable for the finish you want to achieve.

Decide what you want the picture to look like in terms of colour balance and composition. If there is complicated detail, try it out first in a sketchbook or on a scrap of paper if necessary, and consider alternative ways of presenting the difficult bits. Then, when you actually begin to paint, you will already have solved many of your problems.

I have never found painting particularly relaxing, but it should at least be enjoyable and satisfying. If it also pleases others, so much the better!

At various stages of production, sit back and look at your work. In time, you will learn to identify potential, detect any obvious errors, and assess whether you have made progress.

I have two signs in my studio. One says 'START' and the other '100%'. So do it now, and do it wholeheartedly. The better you become the more critical of your work you will be, but you will at least know it is for the right reasons!

Termessos, Turkey

Everywhere one looks in Turkey there are reminders of past glory. This was the first place I visited after a train journey, from north to south, across the mountains: an unrestored amphitheatre nestled in a valley halfway up a mountain. It was unfortunate that I could not paint it on the spot, but I had good photographic references and was able, I hope successfully, to capture later what I had so admired about the setting.

size: 420 x 300mm (16½ x 11¾ in)

Index

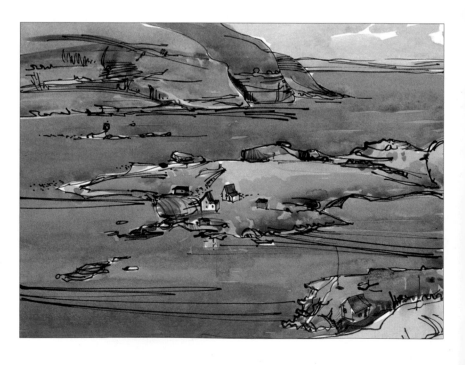

Salvage, Newfoundland

A green island in Salvage harbour. Icebergs were floating down the coast beyond this idyllic scene.

size: 200 X 140mm (8 x 5½ in)